Wedding Photography Revealed

DEDICATION

This book is dedicated to all of the incredible professionals and companies who took the time to submit content to this book. It has been a pleasure working with each of you, in the production of this book. The time you have all taken and the high-quality content that you have all shared has truly gone above and beyond anything we could have ever expected when we first set out to publish this book. Thank you to everyone who made this possible.

Wedding Photography Revealed

Wedding Photography Revealed

The Art of the Perfect Wedding Picture

Benchmark Publishing Group

Wedding Photography Revealed

Copyright © 2016 Benchmark Publishing Group, LLC

All rights reserved.

ISBN-13:978-1537130736
ISBN-10:1537130730

Wedding Photography Revealed

CONTENTS

	Acknowledgments	i
	Introduction	Page 1
1	Nicole Hollenkamp Photography	Page 3
2	IMAGE 615	Page 9
3	Natural Expressions, Inc	Page 15
4	Photos By Orion	Page 21
5	Sarah Alston Photography	Page 29
6	Emily Ku Photography	Page 37
7	Maxheim Photography	Page 43
8	Alvarez Photography	Page 47
9	Michelle Posey Photography	Page 53
10	Keith Pitts Photography	Page 57
11	Viva Expressions Photography	Page 61
12	Fotowerks Custom Photography	Page 67
13	Samuel Guss Photography	Page 73
14	Erin Johnson Photography	Page 77
15	G.E. Masana Photography	Page 81
	Conclusion	Page 93

Wedding Photography Revealed

Wedding Photography Revealed

ACKNOWLEDGMENTS

Nicole Hollenkamp Photography

IMAGE 615

Natural Expressions, Inc

Photos By Orion

Sarah Alston Photography

Emily Ku Photography

Maxheim Photography

Alvarez Photography

Michelle Posey Photography

Keith Pitts Photography

Viva Expressions Photography

Fotowerks Custom Photography

Samuel Guss Photography

Erin Johnson Photography

G.E. Masana Photography

Wedding Photography Revealed

INTRODUCTION

Thank you for purchasing "Wedding Photography Revealed - The Art of the Perfect Wedding Picture". When we set out to publish this book, it was our goal to obtain real world, usable advice, from true industry experts. We are proud and excited to tell you that we have greatly exceeded even our own high expectations, in this regard.

"Wedding Photography Revealed" is truly a compilation of the information that you absolutely must have before you embark on the massive task of planning your own wedding. Our interviewees have shared their knowledge and expertise, to help your wedding go off without a hitch.

Very often, in books that are written in this interview style, you'll find interviews with professionals who are mainly just interested in promoting their own companies. We are pleased to let you know that the contributors to this book have truly put your interests ahead of their own. As you'll see, from reading these interviews, each of our contributors share the exact information regarding what you need to do, and what you need to avoid doing when you're planning your wedding.

Weddings can often be the subject of funny stories... for the guests. These same "funny stories", however, are usually nightmares or unpleasant events for the bride and groom. In the great majority of cases, these unpleasant incidences could have been avoided if the bride and groom had just a little bit of "insider knowledge" when they were planning their wedding. The very nature of most weddings, however, is that it's a first-time and often one-time event, where there are no second chances. The best strategy for getting it right the first time, therefore, is to learn from the experts who have years of experience in the wedding industry.

After you read this book, you're going to have insights and knowledge that it's taken years for our interviewees to acquire. Very often, married couples will look back on their wedding day, wishing they had done certain things differently. After reading this book, the likelihood of you having those same regrets will be greatly diminished. Your wedding is truly a milestone event in your life and we set out to ensure that you get it right the first time, because hopefully, there won't be a second time! After reading this book, we genuinely believe that you will feel confident to plan your wedding with enthusiasm and certainty. So, without further ado, let's get into the interviews!

Nicole Hollenkamp Photography

"Answers provided by *Nicole Hollenkamp*"

"NHP is a full-service photography studio. Offering professional products such as Heirloom Albums, Books, Framed Art, Canvases, Boutique Cards and much more. By offering design services to walk through the process of decorating their homes, we are able to help our clients do more with their beautiful new portraits. Each wedding is customized according to the client's preferences.

We are happy to meet before the client books, although we find it is not necessary. 2 weeks before their date we meet at the venue(s) one last time for a consultation and to finalize details. We show up Early on the day of the wedding to ensure we are ready to go."

Q.) How long have you been a wedding photographer?

A.) I began photographing weddings in 2013 and quickly fell in love with it.

Q.) Do you work alone, or do you have assistants?

A.) I often work alone, however, I have had assistants join me to help with carrying gear or lighting. I am usually the

only shooter, although I have had my husband assist me before.

Q.) What is a good professional photography background?

A.) The photographer should have a solid portfolio and happy clients. My rating online is 5 stars.

Q.) What is your specific Wedding Photography style?

A.) I am a documentary shooter most of the day. I do not usually pose the couple or their guests. I will arrange groupings and pose the bridal portraits. But mostly I catch genuine moments as they are unfolding. I often use available light but once it starts to get darker I light my portraits with off camera flash and a soft box or umbrella. I am doing more lighting during daylight hours now.

Q.) How do you, the photographer, dress for a wedding?

A.) I typically wear All black. In the summer my shirt is professional, but sleeveless with long pants or a floor length skirt and black shoes.

Q.) Will you personally be the photographer at our wedding, or will it be an Associate?

A.) It is usually myself at the wedding. I have not assigned an associate to another wedding yet.

Q.) Do you double book?

A.) I do not double book, although I would be happy to assign another photographer to photograph a wedding with the couples full knowledge that that is what would happen.

Q.) Will you be at our event for the entire day?

A.) I have multiple packages available. It depends on the client's needs and budget. I offer up to 12 hours of coverage with additional hourly rate available after that.

Q.) Can we have photos taken of us getting ready?

A.) Yes, you can. I love photographing this part of the day. It is just as filled with emotions as the rest of the day and you get to really get creative at this time by photographing the rings, and the accessories as well.

Q.) Do you use have backup equipment?

A.) Yes, I bring backup equipment with to every wedding in case my main camera or flashes should fail.

Q.) In the unlikely event that you become ill, do you have an equally great photographer to cover our event?

A.) I do have another experienced photographer that could come in my place. Then I would do the editing of the photos.

Q.) How long does it take to see our photos?

A.) My aim is to have the images ready for the reveal and ordering appointment 3-4 weeks after the wedding. Many Brides and Grooms decide to wait longer to come to see their photos or order their products.

Q.) Can our family and friends also view and purchase photos online?

A.) Yes, Your images can be put online for them to see and order from.

Q.) How long will it be before we receive our completed Wedding Album?

A.) Once your design is finalized and payment is received, it can take anywhere from 3-6 weeks depending on the time of year and how many Albums my lab is creating at the time. They have been super fast in the past, though. And the Heirloom albums are gorgeous.

Q.) What is the process for creating our Wedding Album?

A.) If you indicate a possible desire to have an album I will have a design ready for you to see when you come in for your viewing and ordering appointment. You can take up to 4 weeks to proof it, if you need. Proofing can happen all online. You will be able to view your design, choose a cover and size, add notes to indicate changes you would like and finally approve the design. When clients approve their design they pay any remaining balance before their album is ordered and delivered to them.

Q.) How long will Wedding Albums usually last?

A.) The Heirloom albums are designed to last for generations. They are made of the finest archival quality.

Q.) Do you also do the standard group and family shots, even though your style might be more candid?

A.) Yes, all of my clients that indicate that they want the family shots will get them. I really base what I do off of the desires of my clients. A factor that can play into whether we are able to get a pre-established shot is time. When you have been photographing weddings for as long as I have, you know that something always goes wrong. The wedding party could be running behind or there may be a bad storm no one

planned on. I always do my best by working quickly and efficiently to get all the shots that the couple wants.

Q.) Is there anything you could add that would be helpful in choosing a wedding photographer?

A.) Choose one that listens to you. That asks you intuitive questions that help them get a better idea of what you want. Make sure they are running a legal business and have insurance. Make sure that there is a contract stating what is in included, signed by both parties.

"If you would like to discover more about Nicole Hollenkamp Photography, their information will follow."

Nicole Hollenkamp Photography
www.bynicoleann.com

Please Connect using the following...

Facebook:
https://www.facebook.com/nicole.hollenkamp

Pinterest:
https://www.pinterest.com/motherhoodisjoy

Twitter:
https://twitter.com/NHollenkamp

Instagram:
https://www.instagram.com/nicolehollenkamp

Linked in:
https://www.linkedin.com/in/nicole-hollenkamp-24788b68

Google+:
https://plus.google.com/109042738808556743028/posts

Welding wire:
https://www.weddingwire.com/biz/nicole-hollenkamp-photography-milaca/632f6c925ee0a589.html

Download my APP from:

IMAGE 615

"Answers provided by Victoria Buck"

"Formally a photographer in West Virginia; IMAGE 615 was created by entrepreneur Tori Buck, with 13 years of experience in Wedding Photography. She moved to Cross Plains, Tennessee to provide wedding services to the huge Nashville Wedding market, opening IMAGE 615 in 2015."

Q.) How long have you been a wedding photographer?

A.) 13 years.

Q.) Do you work with an assistant, additional photographers, or alone?

A.) Alone and Assistance if required.

Q.) What would be considered a good professional photography background?

A.) Fields of wheat, clouded sky, with a beautiful barn or country setting. Scenic. Cityscapes, grungy alleyways, etc., It really depends on the vibe on the session and the requests of my clients.

Q.) Does a wedding photographer require a specific license?

A.) No. But I do have an Associate in Arts & Science with a minor in Graphic Design and did attend Business School. But for a business, you do have to acquire a business license.

Q.) What is your specific Wedding Photography style?

A.) Creative and Traditional, I really like adding creativity to the ordinary or an original idea.

Q.) Do you recommend a specific style of photography for weddings?

A.) This depends on my client's needs, and will be known after consulting with the Bride and Groom. I specialize in creating their vision with added flair and creativity. So the real answer would be; what will work with their requests for their session or event.

Q.) Is it possible for the photography style to be chosen based on the wedding environment itself, or?

A.) It does play a role in the type of photography, location, and style, but it can be separated by choosing an alternate location for the Bridal Session.

Q.) What would be required to get the best photo shoot possible?

A.) For myself, to get the best photo session possible, I pre-plan every session. I take notes of what the client would like to see or expect, and add my ideas and work up a pre-plan of what, when, where, and pose those ideas. I also do this to

ensure there is no time wasted during their session. Absolutely pay attention to detail! A necklace not positioned correctly can ruin a good photo.

Q.) If chosen, would you be the photographer at our wedding, or would it be an associate or assistant?

A.) I like to do one on one consultations. This gives the Bride and Groom a look at my previous work and also gives me an idea of what they are looking for and what they are not looking for. You get a feel for their vision of their special day. I would definitely be the photographer of the wedding/event.

Q.) Do you double book, and if so, what would this require?

A.) I NEVER double book. I like my session or event strictly for my client, in the case of a timing change or if we run over the time allotted for an event or session, or anything else that may come up that you don't have control of.

Q.) How do you, the photographer, dress for a wedding?

A.) I like to promote my company, so a "Golf" type white shirt with company logo, black pants, and shoes. I dress comfortably because there will be a lot of "being on your feet", as well as a lot of "bending and stooping."

Q.) Would you be at the event for the entire day?

A.) For the amount of hours agreed upon during our contract signing for your event, additional time can always be purchased at any time.

Q.) Can we have photos taken of us getting ready?

A.) Absolutely!!! That's the start of the beginning of your wedding day! A must!

Q.) Do you use, or have backup equipment?

A.) Absolutely! Always bring back up lighting, camera, batteries and more! Never want to be short or in need of anything, this is why pre-planning of events is a must do!

Q.) In the unlikely event that you become ill or something comes up, do you have an equally talented photographer to cover our event?

A.) I don't cancel and I don't do a backup on my events. I don't allow anyone to stand in on the representation of my work or craft. Only once in my 13-year career has an assistant had to take my place at an event.

Q.) How long does it take to view the images once the wedding shoot has completed?

A.) One week to two weeks. Depends on how many images were offered in their event package.

Q.) Can our family and friends also view and purchase photos online?

A.) Absolutely! I offer online galleries, online print ordering, and proofing right on my website and you may also order 350+ photo type products as well.

Q.) If ordered, how long will it be before we receive our completed Wedding Album?

A.) 2-3 weeks at most.

Q.) What is the process for creating a Wedding Album?

A.) Going through all images taken during the event, the editing process, and to weed out which were the best of the best.

Q.) If taken care of, how long should Wedding Albums usually last?

A.) 70+ years uncovered.

Q.) Do you also do the standard group and family shots, even though your style may not cover these areas?

A.) Yes! This is part of the event. We surely want to capture the family that made it all possible.

Q.) Is there anything you can add that would help in choosing a wedding photographer?

A.) Always check credentials. Look at their most recent work. Check their reviews. Make sure they are actually licensed to do the type of work you are looking for. Always ask questions.

"If you would like to discover more about IMAGE 615, their information will follow."

Victoria Buck
IMAGE 615
4503 Jernigan Road
Cross Plains, TN 37049
615-389-9331
www.image615.com
image615@outlook.com

Wedding Photography Revealed

Chapter 3

Natural Expressions, Inc.

"Answers provided by - Dan O'Keefe"

"Natural Expressions, Inc. We are a full-service photography studio specializing in both portraits (families, high school seniors, children, and newborns, etc.,) as well as events (weddings, Bar and Bat Mitzvahs, parties, etc.,). We have been in business for over 25 years. Our goal is to tell your story."

Q.) How long have you been shooting weddings?

A.) We have been shooting weddings for over 15 years.

Q.) Is there a special license required for being a wedding photographer?

A.) No, unfortunately, there is no license required. Digital cameras have lowered the barrier to entry for photography to the point that anyone who finds who buys a camera can call themselves a "professional." There are FAR too many photographers with no training at all.

Q.) Do you travel for destination weddings?

A.) We do. But we do not get those requests very frequently.

Q.) Is there a reason why the "wedding photography" investment is so costly?

A.) With a true, educated professional photographer or studio, the time investment on their part is very large. The effort put into editing the photos to make the most special day so special requires an investment. If people want to find a "photographer" who will charge $500 for photos and a disc, they can. Unfortunately, you get what you pay for.

Q.) Is there a "base cost" of wedding photography?

A.) The cost of wedding photography varies GREATLY from studio to studio.

Q.) When photographers say "a DVD of images"; how many would that be?

A.) Again, that number varies GREATLY from studio to studio. For a typical 9-11 hour wedding at our studio, people can expect between 600 to 1,000 fully-edited photos.

Q.) Do I get to keep the RAW files?

A.) I have, on very rare occasions, had that request. If someone would like the raw files (which are VERY large), we will give them the raw files of all the files we JPEG. They have to provide flash drives for those files.

Q.) Will the negatives be available anymore with digital imaging?

A.) Every professional should have the raw files and Jpegs.

Q.) Do you still shoot weddings using film?

A.) We no longer use film. I love film, but we converted fully to digital when it got too difficult to routinely find and buy the film.

Q.) How many weddings do you shoot a year?

A.) We have dropped down to around 12 weddings a year. The number has dropped, primarily because we now photograph around 45 Bar and Bat Mitzvahs per year. Those events will hire a photographer up to 2.5 years in advance. So, we have many dates unavailable to the average bride who plans her wedding 12-14 months out.

Q.) How long does it typically take for the images to be ready?

A.) I can say that it varies with the time of year. During the Fall (seasonally our busiest time), it can take 3-4 weeks. During most of the year, it typically takes 2 or so weeks.

Q.) Can I share my pictures on Facebook and other social media sites before making the initial investment?

A.) I'm not quite sure what this question is asking. Before the initial investment, we generally have not taken any photos.

Q.) What if I choose not to have my images used on your blog or in magazines, do I have any rights?

A.) We never use images if the person(s), family, etc... do not want us to.

Q.) Do we provide meals for the photographer and crew at our wedding?

A.) Meals should be provided to your photographers. We typically will be spending 9 (possibly more) hours with you. It is a long and energy-sapping day. You want us to be fed.

Q.) Do you provide a list of partner vendors you work with before the wedding date?

A.) We are always happy to pass along the names of vendors we trust and like.

Q.) Is there anything you can add that would help in choosing a wedding photographer?

A.) Take the time to research photographers. Ask to view entire weddings that they have shot (not just an All-Star group of 20 or so photos).

Understand that there are many unqualified photographers out there who feel that Photoshop can fix all of their mistakes.

The focus has got away from capturing the correct image. Quantity does not make up for quality; and photoshop is a tool, not a savior.

I am a member of multiple photography groups on social media, and I have seen a woman, WHILE AT AN EVENT, post a photo that was half black, and desperately ask "What am I doing wrong????!!!!" She, obviously, then had to wait for an answer before she could take useful photos. Again, all of this WHILE at the event. She was using her flash at too high a shutter speed (hence, the photograph had half of the image blocked by the shutter). You do not want to trust your most important day to someone who is learning on the fly.

Wedding Photography Revealed

Also, try to go with a studio that will be sending more than one photographer. And only use a studio who will allow you to meet your photographers (not a company that signs events and then contracts others to perform the work). If they will not tell you who will be at your wedding, consider it a VERY large red flag.

Finally, please go and meet with prospective photographers face-to-face. You should like your photographer - truly like and get along with them. You will be spending more time with them than with any other vendor. And.... Because of the nature of what we do (take a camera and focus it on you - a position many do not particularly enjoy), you want a photographer who helps you be yourself, puts you at ease.

Most importantly..... HAVE FUN!!!!!! It is your wedding.

"For more information about, Natural Expressions, Inc, their information will follow."

Natural Expressions, Inc.
Dan O'Keefe (President)
Christine Sheeren
(713) 665-7140
natexpressions@sbcglobal.net

Wedding Photography Revealed

Wedding Photography Revealed

Photos By Orion

"Answers Provided by - Kathryn Davidson"

"Photos By Orion is a 3 photographer studio offering wedding, portrait, senior, business, shimmer, and fine art photography. While we work mostly within the Willamette Valley and along the northern Oregon Coast, we are willing to travel to give our clients the photos they want at the highest quality we can provide."

Q.) Do you only photograph weddings?

A.) No. We photograph a number of different, but equally precious, moments in someone's life. We start with babies and children's portraits and continue with senior and engagement photos, and then wedding photography; we then take the family, business and shimmer portraits, and complete the circle with maternity photos of the next generation.

Q.) How do we reserve you as our wedding photographer?

A.) Our booking process starts with a consultation where you share your great wedding ideas and we discuss options. We then sign a contract and you put down a 30% deposit, which secures your date.

In general, booking your wedding photographer requires you to meet with them, sign a contract, and put down a deposit to

secure the day. The majority of photographers require a 50% down payment.

Q.) What is the Photojournalistic Wedding Photography Style?

A.) A Photojournalistic wedding style is when the photographer takes a hands-off approach and a fine art, artistic eye to the wedding. Most photographers who use a photojournalistic style do not interact with the couple during the wedding but focus on their craft. Many couples think that photojournalistic and candid are similar but there is a lot more art to getting photojournalistic photography right. The photos are typically very dynamic, are in black and white usually, and look amazing on your wall. There are also, typically, a lot fewer photos delivered with a photojournalistic style because the photos taken are so carefully chosen.

You take wedding pictures with a digital camera, but do you make inkjet prints? I've heard that inkjet prints tend to fade.

Traditional inkjet prints made on a consumer grade printer can (and usually do) fade over time. I print through a local, professional printing house that uses professional grade printers and archival papers that hold the ink so much better that they can survive for almost 100 years without fading.

Q.) If you are using a digital camera, how do you make black and white wedding prints?

A.) With digital cameras, changes to the photos are done in the post processing phase, usually in a "digital darkroom" type program. Within the program, the photographer can then take out some or all of the color in a photo to create a black and white image.

Q.) Some photographers do not allow (or severely limit) guest's taking pictures. How do you handle this?

A.) Guests taking pictures is something every photographer handles differently. I have photographed weddings where almost no guests took pictures and I have had others where I was followed around by multiple family members trying to take every shot I was taking. Usually, I am not bothered by guests taking photos, but I ask my couples to remind their guests that they have hired a photographer so please let them do their job. It is when guests get in the way, sometimes literally stepping in front of me to block my shot and take it themselves, that I have a problem with guests taking photos. Thankfully, that has not been an issue much over the past 12 years.

Q.) How should I find a wedding photographer?

A.) Finding your wedding photographer is no easy task. Your photographer will be very close to you both all day, so it needs to be someone you are comfortable being around and trust. To find just the right person or team, you should start by looking at the photographer's style. This is based on the type of photographs they take, and how those photos look once they have been edited. Once you find a style you like, then you should check out pricing and call your favorite 5 photographers. While many photographers will publish their pricing on their websites, there are still some who do not for various reasons, so if you love their style but can't find prices give them a call anyway. There are many "wedding marketing gurus" out there telling photographers to NEVER post pricing so potential clients have to call. While I personally don't follow this line of thinking I know photographers who do.

When you call your five favorite photographers, schedule meetings with them (unless their pricing is too far out of your budget, then ask what options they offer while you have

them on the phone). Meeting a photographer face to face is the only way to get a good sense of personality.

The 5 Do's for finding your photographer:

1) Do make sure they are a good fit both stylistically and personality wise for you.
2) Do make sure they are a legitimate business operating in your state (you would be surprised how many aren't) as you are more likely to get everything you are promised in your contract if they are following all the rules.
3) Do see whole weddings from them. Any photographer can get 1 or 2 great images out of thousands shot at a wedding, but it takes an artist to get hundreds of great images every time.
4) Do ask how long it will take to get your photos back and get it in writing in the contract.
5) Do meet in person before booking someone.

The 3 Don'ts for finding your photographer:

1) Don't skimp on your photography, this is how you will remember your wedding day forever, so get the best you can afford.
2) Don't book someone who makes you uncomfortable in ANY way. Your photographer and coordinator are the only vendors who are with you the whole time. Your photographer will be with you from getting dressed through the reception, so it needs to be someone you are comfortable having around for intimate moments.
3) Don't book ANY photographer who doesn't have a contract. That is worth repeating: NO CONTRACT, NO PHOTOGRAPHER! Almost daily I read or hear stories of couples who hire someone (this is especially true of relatives who want to play photographer) and they either don't get photos or don't get everything they were promised by the photographer. Without a contract, there is very little legally you can do in this situation, so protect yourself and only work with a photographer, (or any wedding vendor for that matter), who has a contract

expressly stating what you get and what your options are if those things are not provided.

Q.) What questions should I ask a prospective wedding photographer? Better yet, what should I ask the photographer doing our wedding?

A.) Some of the questions that you should always ask prospective photographers will be the following:

- If I book you, will you be the photographer who actually photographs my wedding?
- How long will it take to get my photos once the wedding is over?
- What is your backup plan if something happens to you or your equipment before the wedding?
- May I see a copy of your contract?
- What kind of planning will we do together before the wedding?
- Do you have a list of photos you recommend to help me get started?

Questions to ask the photographer who will be doing your wedding:

- Are there any concerns you have, or that we should be considering, regarding our wedding photography, such as lighting or background issues?
- If we want you to stay longer than we contracted for, is that possible?
- How will you work with our other vendors to make our day go smoothly?
- Will you do a venue walk through with us before the wedding?
- When will you be in contact next?

Q.) If you only do wedding photography part time - shouldn't I be looking for someone who shoots weddings full time?

A.) Yes, you should be looking for a full-time photographer and I am one. Your wedding day comes only once and you should have someone there who will be as invested in it as you are! A full-time photographer is usually more experienced in many different situations and therefore better able to handle anything that comes up during the course of your wedding. This means the best pictures possible, even when the conditions are less than ideal.

Q.) Do you have a page of wedding links?

A.) There are many resources available to couples planning a wedding. Some are more reputable than others, and some are more informative than others. Some of the best resources though are your vendors. If they have been in the business for a while, then they will have worked with many other vendors and will be able to give you recommendations of where to start, how to make things go smoothly, look great, and not cost a fortune.

Q.) I am planning a 5:00pm wedding, with a departure via a stretch limo. Obviously, photos of the departure are important to me. When does the sunset and how late can a photo be taken and still look good?

A.) Sunset changes with the time of year. In the late summer here in Oregon sunset is usually around 9pm with the best lighting being the last 20 minutes before sunset. If your photographer is a natural light photographer you will not want to go past sunset as taking great photos that don't look grainy gets significantly harder once the sun is down without artificial lighting. If your photographer is comfortable with low lighting, artificial lighting/flash photography, (which we are) or if your venue has significant lighting available, then time and darkness do not really matter.

Q.) Do you travel out-of-state to do photography?

A.) Yes, we do. To date, the furthest we have traveled is to Alaska for a wedding, but we welcome the challenge and the opportunity to photograph in new and/or exotic locations. It would then be important to get to the destination at least 2 days before to get a feel for the lighting and environment before attempting to photograph somewhere you have never been before.

Q.) Do you create wedding albums for your customers?

A.) We do offer both traditional heirloom leather albums and more modern photo-book albums for our clients.

Q.) Is it important for my photographer to shoot medium format as opposed to 35mm? Or, what wedding photo equipment should he use?

A.) It is not as important whether your photographer shoots medium format or 35mm "full frame." What will matter is how your photographer uses the equipment they have to capture what they see around them. Your wedding photographer should use a professional grade camera, but mostly because it will allow you to make larger prints without losing the quality of the image.

Quality of Photographer x Quality of Equipment = Quality of Photography.

A great photographer with crappy equipment will still produce good photos. A crappy photographer with great equipment will make ok photos sometimes. A great photographer with great equipment will make stellar photos every time.

Q.) Do you make exceptions to your criteria list?

A.) You will almost never find hard and fast rules for us. We will do everything we can to give our clients the best we can do, and sometimes that means doing things differently than we have in the past. We do our best to be open and communicative with our clients and hope they do the same with us. When we are all on the same is when the best work is done.

"For more information about, Photos By Orion, their information will follow."

Kathryn and Orion Davidson
Photos By Orion
1448 12th St SE, Salem, OR 97302
503-871-8417
contact@photosbyorion.com
www.photosbyorion.com
www.facebook.com/photosbyorion

Sarah Alston Photography

"Answers provided by - Sarah Alston"

"I am a Seattle based wedding, boudoir, event, family, newborn and senior photographer. If you ask me what I love to photograph the most, my answer will likely lean toward whatever shoot I happen to be working on at that moment... although I DO have a special place in my heart for wedding photography.

I try to keep my photography "real"... I want my clients to have fun and laugh and play... this is when they will look the most natural. I want people to look forward to their photo-shoots instead of dreading them, which is why I don't have a studio. My clients choose a location they love, a place that means a lot to them or a place that they have memories of, and we shoot there. It makes every photo-shoot so personal and meaningful." – Sarah Alston

Q.) Do you bring assistants or 2nd shooters with you to weddings?

A.) I almost always have a second shooter at weddings. My husband used to shoot with me, whom I LOVED, but he got promoted at his job and decided that working 6 -7 days a week was too much for him. I whined and begged and called him a sissy, but it didn't convince him to stay with me. (I guess he wanted to sleep occasionally...) Now I have a few

wonderful second shooters that are my "go to" girls for weddings, and I just adore them.

Q.) What is a "first look"?

A.) In the past, the tradition was that the groom isn't supposed to see the bride before the wedding ceremony, so the first time he saw her was when she was coming down the isle. As wedding photography and even wedding traditions, in general, have evolved, many couples opt to have their photos taken before the ceremony, usually for time's sake. It's an important moment when the groom first sees his beautiful bride, one that we want to make sure and get photos of. When I set up first look photos, I want to make sure that the setting is gorgeous, and that we can even have a little fun with the photos. I've had couples be blindfolded for the first look, or had the bride cascade down a flight of gorgeous stairs, and recently even had a couple meet at a corner under the street sign of "Happiness St."

Q.) How do we book you for our date?

A.) Usually, my clients shoot me an email or give me a phone call after they've looked at my website. From there I set up a face to face meeting with them so we can make sure that our personalities click. After all, you are spending way too much time with me on such an important day to realize that you don't like my personality or can't stand me. Once we have our meeting and if the client decides that they want me for their wedding, we sign contracts and it's a done deal!

Q.) How long are you with us on the day for?

A.) It just depends on how many hours you choose to have me there. I have my prices set up a la carte so that each client gets exactly what they want. You can hire me for 2 hours, or you can hire me for 12 hours. It's totally up to each client.

Q.) When should we do the pre-wedding shoot?

A.) Again, this depends on what each client wants. Some couples want to send out Save the Date cards, or use the photos for their invitations, so we go by whatever timeline they have set up for sending out the photos. Usually, I do engagement sessions 3-4 months before the wedding.

Q.) Do you travel and what do you charge for this?

A.) I do travel for weddings! So far I have shot weddings in New York City, Santa Fe, and Colorado Springs. The cost of each destination wedding is different depending on the individual circumstances.

Q.) What's involved in booking you for our wedding?

A.) I keep it pretty straightforward. I require a face to face meeting first. Then, if you decide to book me, I have a contract for us to go over and discuss. We sign the contract and come up with a timeline for the day. The deposit for wedding photography is 1/3 the total cost of the final price. The rest of the amount is due one month before the wedding.

Q.) How many weddings do you book a year?

A.) I typically shoot between 10-15 weddings a year. I have a husband and 2 kids that take up a lot of my time, and I'm also busy doing other photoshoots during the week such as families and newborns, so I try to keep the number of photoshoots, I do, reasonable and not overwhelm myself. My days are never dull!

Q.) Why is there such a large price range among different wedding photographers?

A.) Every photographer decides what they want to charge, and every photographer has their own targeted market. Because of this, every photographer's price will be different.

It also depends on how long you've been in the business, how busy each photographer is (how high of a demand they are), what their overhead costs are, how long they spend editing, and what expenses they have (marketing, outsourcing of editing, taxes, etc.). Figuring out pricing is a really personal choice and one that usually takes a lot of time to figure out.

Q.) At what point in the wedding planning process should a couple book a wedding photographer?

A.) As soon as possible!!!!!! Most wedding photographers book up at LEAST 6-10 months in advance, so if there is a photographer you have in mind, get them on your calendar stat!

Q.) What should a couple look for in a wedding photographer?

A.) First of all, take a look at their website. Check out their photos... Make sure you love their style. Look for the way they pose people, the way they use light (no harsh shadows on people's faces or overly bright photos that lose detail), see if they get shots of wedding details, make sure you like the way they edit, make sure you love their use of color. You should pull up a photographer's blog, and feel a jump in your heart when you look at their portfolio. If you don't OOHH or AAAHHH in the first 15 seconds, they probably aren't the photographer for you.

Next, when you are looking at a photographer's portfolio, whether it be online or in person, be absolutely sure that you can view "wedding stories". What this means, is make sure that they give you an example of a few weddings from beginning to end. Any photographer can take the 4 best photos from every wedding and post that on their website as their work and look like they are fantastic photographers. The thing is, those 4 photos might be the ONLY good photos,

they got the whole day. You need to be able to see that they can photograph the entire day and roll with the punches of wedding photography: drastic changes in lighting, capturing emotions that are so important, but happen in an instant, being able to switch lenses in time to catch zoomed in shots as well as wide-angle, etc., are key to good wedding photography.

After those two things, the MOST important thing is to meet with your photographer and make sure you LIKE THEM. Couples, particularly the bride, will spend HOURS with their wedding photographer. Weddings are stressful enough... you don't need to be annoyed or mad at your photographer the whole day. Make sure you feel comfortable with your photographer. Make sure they get to know you and make sure that you can get to know them, as well. They are a huge part of your day... more involved in the wedding than even the wedding coordinators. We are there while you get your makeup and hair done, put your dress on, see your groom for the first time, see your dad or mom for the first time, say your vows, cut the cake and dance the night away. Make sure you like who your photographer is!

Q.) What should a couple beware of with certain wedding photographers?

A.) Never give a photographer money without signing a contract. If they want a deposit or the full amount without signing a contract, run away! Also, read the fine print of your contract and make sure you voice things that you aren't comfortable with. My wedding contract is 7 pages long. If a photographer wedding contract seems really short, then all of your bases might not be covered and you could end up getting screwed.

Make sure they have a great website. If they don't have good portfolio work up on their site or at least have proofs for you to see, don't hire them.

Don't hire a photographer who "just got their camera" or is "an ammeter giving you a great deal". Beware of photographers who don't know how to use their cameras and are thinking they can just make a quick buck by shooting your wedding. These people have no experience and will likely miss a lot of shots that capture what your day was all about.

Watch out for photographers who can't answer any questions you ask them... be specific when talking to them. Ask them about their camera, ask them how they would handle certain situations, ask them for photo posing ideas. If they look unsure or scared of answering you, they likely don't have a lot of experience and you'll probably be disappointed with your photos.

Q.) How should a couple determine their wedding photography budget?

A.) That is a personal decision for every individual couple. Some people value photograph more than other details of the wedding, so they will skip on those and put the extra towards photography. Some people don't put as high of a priority on wedding photography, so they will spend less.

Determine the total amount that you can spend on the wedding. Then I would sit down and make a list of all of the things that are top priorities in the order of their priority. Then from there, figure out how much you can spend on each item.

Look at what the photographers are like in your area. Find the top 10 photographers that you LOVE. Then you can judge what your style is and how much your perfect

photographer costs. If they are in your budget, cool. If not, as least you know what you are looking for and can go from there. You may find a photographer that you just HAVE to have, and would be willing to sacrifice those amazing napkin ring holders or the very pricey cake topper so you can afford them.

Q.) What equipment should a wedding photographer have?

A.) This is a really controversial issue in the photography world. I shot with a Canon 40d for the first 4 1/2 years of my business. It's not a bad camera, but definitely not top of the line, either. The trick is that I knew how to USE my camera... and I ROCKED it. Even though I now shoot with a Canon 5d Mk2, I still love my little 40d. I knew how far I could push it. I knew what it was capable of. I knew its limits, and I knew how I could manipulate the situation to get the result I wanted. Don't get me wrong, having awesome camera equipment is important for getting the perfect shot. That being said, I don't think anyone can judge a photographer solely based on what equipment they use.

A professional photographer should, however, have a good SLR camera, and a good flash. They need to have extra batteries and an abundance of memory cards. They need to have a variety of lenses, both zoom, and wide angle. Those are the basics that no photographer should be without.

Q.) Do prices typically vary for off-season or weekday weddings?

A.) For some photographers, they will charge less on a weekday vs. the weekends. I charge the same for both because of the amount of work on both the day of the wedding, as well as post processing, remains the same no matter what day I shoot.

Q.) Is it possible to get black and white photographs as well as color photographs, or do couples typically need to decide between one or the other?

A.) I go through and do an initial edit on all of the photos and decide which ones should be in color and which ones should be in black and white. I have a pretty good feel for which is best for each photo. Once I show the edited images to my clients, they can then go through and request any changes that they'd like. Sometimes no changes are necessary and they love how I did it. Other times, people will want me to re-edit 20 or 30 photographs, doing anything from black and whites to removing blemishes, to editing out power lines, or some other unsightly background distraction.

Thank You...

"For more information about, Sarah Alston Photography, their information will follow."

Sarah Alston
Sarah Alston Photography
www.sarahalstonphotography.com
sarah@sarahalstonphotography.com
www.facebook.com/sarahalstonphotography
253.332.1444

Chapter 6

Emily Ku Photography

"Answers provided by - Emily Ku"

"Emily Ku Photography is based in Las Vegas and accepts a limited amount of weddings a year to give personalized attention to each couple. Brides fall in love with Emily's ability to capture the moments of their day and the level of service that Emily Ku Photography delivers. Emily's upbeat attitude and energy is total proof that she cares just as much about your wedding as you do. From the time you book your wedding to your big day, Emily Ku Photography is in contact with you every step of the way. Emily Ku Photography will offer you luxury albums, wall art, and high-resolution images you'll be able to enjoy your wedding day." – Emily Ku

Q.) Do you back up the images you take at weddings?

A.) Yes, in 3 different locations: my computer, an external hard drive, and in a cloud. I take backup very seriously and do it as soon as I get home from a wedding. I believe this is crucial because you never know what could happen.

Q.) Will I get my photographs on a DVD?

A.) Yes, they are included in my packages.

Q.) Are the pictures on the DVD edited?

A.) I only deliver all the good images in the final delivery, so I take out all the repetitive photos and the ones where people aren't looking their best. I also do basic edits such as exposure and color correction and apply some artistic effects.

Q.) Why will I order pictures from you if I receive a DVD with hi-res images?

A.) Online ordering of images is available for all clients, and I encourage my clients to purchase prints from me because I retouch the images that go to print, such as minimizing fine lines and wrinkles, blemishes, etc. It's a very time-consuming process that I can't do for every picture, especially if I am delivering 800 photos, so that is reserved for pictures that you order. Also, my prints come from a professional lab which is color corrected and printed on thicker paper than what you would get at a drugstore. Drugstore prints vary in quality and aren't color corrected, so you may end up with skin tones looking too green or magenta.

Q.) How many pictures will I have on my DVD and do you include all of the pictures you take?

A.) The number of pictures will vary, but at a typical wedding, I would say expect anywhere from 60-100 images per hour. I tell couples to not focus too much about the number of pictures that they are receiving, but the quality of the images. 10 amazing images will be better than 20 mediocre images or worse, 20 very similar images.

Q.) Why will I take bridal portraits or engagement session before the wedding?

A.) I think engagement sessions are really important because you want to capture that time of your lives and it's a great way to get to know your photographer. Also, think of it as a

test run to your wedding day pictures. Most people have never had their pictures professionally taken (with the exception of school pictures), so it's a great way to get comfortable in front of the camera. Your wedding pictures will turn out better too, because you've had practice!

Q.) When do I book my Bridal / Engagement / Boudoir Session?

A.) The best time to book a session is about 4 weeks in advance to ensure availability.

Q.) How long is the portrait session?

A.) Typically 1-2 hours, depending if we are shooting in one location or multiple locations, and if there are any outfit changes.

Q.) What to expect at the bridal portrait session and can I take bridal portraits at the wedding instead of booking a separate session?

A.) If you decide you want to take bridal portraits at the wedding instead, please make sure to allow enough time in your timeline. Often, getting ready with items such as hair and makeup will tend to make things run late on the wedding day, so there's usually not a lot of time for bridal portraits, so it's best to have a separate session if bridal portraits are really important to you.

Q.) Where will you photograph our engagement session?

A.) I shoot all my engagement sessions on location. I collaborate with my couples and we brainstorm places that fit their personalities.

Q.) What should I wear to an engagement session?

A.) I always tell my couples to wear whatever they feel comfortable in. I find that bold, solid colors work best. If a

couple is unsure of what to wear, I'm happy to help them with wardrobe selection.

Q.) How long before I see my proofs?

A.) Typically within 4 weeks. I always try to turn around images as fast as I can, but weddings always tend to cluster at certain times of the year, so it's a very busy time.

Q.) When do you typically arrive at the wedding and what to expect on my wedding day?

A.) I arrive a little earlier than scheduled so I can get settled in and meet everyone in the wedding party before I get started. I photograph events as they are happening and do minimal direction so as not to interrupt the flow of the wedding day. I want couples to enjoy their day and barely remember that they saw me. Afterward, it's great to see their reaction when I've captured a moment and they didn't even know I was there to capture it!

Q.) What is a first look?

A.) A first look is when the bride and groom see each other for the first time before the wedding in a private setting. It's actually one of the only parts of the wedding day where the couple gets to spend some time alone.

Q.) What is an "after" session?

A.) A day after session is a great alternative to taking bride and groom portraits on the wedding day. Many couples want to spend their wedding day with friends and family and don't want to sneak away for 2+ hours to take portraits, so they opt to do it the next day. Couples love it because they don't want to worry about entertaining guests and are a lot more relaxed.

Thank You...

"For more information about, Emily Ku Photography, their information will follow."

Emily Ku
Emily Ku Photography
www.emilykuphoto.com
emily@emilykuphoto.com
702.799.9358

Chapter 7

Maxheim Photography

"Answers provided by - Paula Maxheim"

Q.) Can my family and friends order prints?

A.) Absolutely We provide hard copies in proofs or we can upload all images to a website where all images can be viewed and purchased and shipped to all those that order-- taking the bride and groom out of the "photo or album ordering business" of family and friends/

Q.) What about a Photo CD or Slide Show?

A.) The inclusion of a CD or slide show will be included in some packages or can be ordered Ala carte. Copyright release of images will be discussed prior to the wedding, but the caveat is if they take their CD/DVD to Wal Mart-Walgreens-Costco, etc., The quality may not be good and we are not responsible if the images are not printed by a professional lab.

Q.) Can we order a formal album or parent albums?

A.) We custom design our wedding albums. Samples of these albums can be viewed at our website www.maxheimphoto.com.

Q.) What style do you shoot?

A.) Photojournalistic & traditional

Q.) What type of equipment will be used?

A.) We use both top-of-the-line Nikon and Canon, upgrading as needed, which often is every year or two.

Q.) How would you define your style of photography?

A.) We have been in business--serving Iowa for over 77 years. We do both traditional & Journalistic but through conversations and consultations, I determine what the couple prefers and what they want as the final product. Our experience allows us to give the couple what they want.

Q.) How involved are you in the process of consulting me in terms of my photographic goals?

A.) I am "consulting" from the phone call of inquiry to the delivery of the album. We are a very personal - one to one- family business!

Why did you decide to specialize in wedding photography primarily? I have worked in the family business part time as a wedding photographer since 1970, and full time since 1985 when I purchased the family business.

Q.) Have you received any formal training as a photographer?

A.) My father was the youngest photographer in Iowa to receive a Masters in Photography. My training required that I work as his apprentice for 5 years and a Master teacher he certainly was!

Q.) If I decide to hire you, will you photograph my wedding?

A.) You will always consult with the photographer that will photograph your wedding. We feel it is very important to get to know the couple before their wedding day and discuss any concerns they have regarding family dynamics or photo issues (like closed eyes-crooked smile-balded spot-bad side,

etc.,) Fracture families - same-sex marriages - blended families have a multitude of family issues that are very important to be aware of prior to the wedding day. The photographer travels with the couple through the most publicly private moments of their lives and being aware of the family dynamics is essential to get the images the couple wants.

Q.) Is it just you or you work with a second shooter?

A.) We do shoot in double if the length and size of the wedding will demand it. This is a decision arrived upon by both the photographer and the couple.

Q.) I like your work. Can I see an entire wedding?

A.) You can see entire wedding albums on our website www.maxheimphoto.com or when you come into the studio for a consultation. We feel it is very important to see an entire wedding, not just a "few best shoots" from several weddings!!

Q.) What do I do to hire you for my wedding?

A.) There is a non-refundable deposit of $500. This reserves a wedding for us--your photographer and guarantees the couple they will have a photographer. This deposit is deducted from future purchases.

Q.) What if something happens to you and you cannot make it to my wedding?

A.) We have backup photographers if this occurs. In our 77 year history, this has only happened once when we had a death of a family member and a very capable photographer filled in.

Q.) Do you have backup equipment that you bring with you?

A.) Absolutely! We bring 3-4 backup cameras and equipment.

Thank You...

"For more information about, Maxheim Photography, their information will follow."

Paula Maxheim Owner
Maxheim Photography
www.maxheimphoto.com
515.255.2159

Chapter 8

Alvarez Photography

"Answers provided by - Rina Alvarez"

"In a perfect world, I would photograph weddings every day. But people don't usually get married during the week. Love is a beautiful thing and capturing that love is what I do. The cake will get eaten, the music stops, the fashion gets outdated. The photos will be there forever.

Alvarez Photography is an affordable photography company that allows the ease of totally customizable packages to fit everyone's needs. I have been told I can bring the best out of people in the photographs I take. It is my goal every time." – Rina Alvarez

Q.) How long have you photographed weddings?

A.) I have been photographing weddings for 3 years. I am 31 years old and I have found my calling in life! I love what I do and it took me my whole life to figure it out. A lot of people want to be photographers and go to school for it and that is fine for technical purposes, but with that said, the honest truth is you either have 'the eye' or you don't. I can go to school to be a professional hip-hop dancer, but if I am uncoordinated and clumsy like I know I am then it probably will never be my career, more of just a hobby and an extreme waste of money. The end result is a lot of unhappy clients and a failed business. The true talent in photography shows through the photographer's photos.

Q.) Do we get a disc of high-resolution files?

A.) I do provide a disc of all images captured on your special day (edited and unedited photos included) with every package I have to offer, no extra cost. I also give the clients all the copyrights so they can print as much as they like. Some photographers charge extra for this. They are the clients' pictures. End of story. They should see everything they paid a photographer for with no additional charge. Some photographers like to nickel and dime their clients and this is one they get away with it. (Printing – discs, etc.)

Q.) How many photos should I expect to receive?

A.) The number of total photographs clients will receive varies depends on how many hours they hired me for. If it is a simple ceremony-only shoot, then expect 200 photos minimum. Every hour you add, basically add another 100 photos.

Q.) Do you give us every photo you take?

A.) Yes to a point. If there is an occasional blurry photo, or an extremely unflattering photo (especially of the wedding party) then they will be deleted before they ever go on the disc. I know I don't like seeing unflattering photos of myself and I don't think anyone else does either.

Q.) Can we give you a list of photos we would like to have you take?

A.) Clients are encouraged to Google examples of photos they like or want to try and replicate. Making the clients happy is what I am here to do. Photos last forever so if they aren't what they want then why take them? Giving photographers examples of shots they desire will make the photographer's job a whole lot easier.

Q.) Do you edit your photos?

A.) I edit my photos with Adobe Photoshop CS4. You can see from my website that it allows me the versatility to set a mood in a photo with color and manipulating light and shadow and detail. Wonderful program - I highly recommend it.

Q.) How long after the wedding will we receive our photos?

A.) Expect no less than 2 weeks, but no more than 3 before receiving the completed disc with all photos and copyrights. Hundreds of photos take a little time to edit. This is standard practice among wedding photographers. Some take longer if they are involved with printing albums.

Q.) Do you back up your photos?

A.) I back up every photo I take on separate master files and external hard drives. (Knock on wood) If my computer ever crashed, I want to be prepared to not lose all of my work.

Q.) What kind of equipment do you use?

A.) Nikon, Nikon, and Nikon. Everyone has their favorite, but Nikon has the most adaptable equipment with the most options. This is a debate amongst photographers that will never end, but I am team, Nikon.

Q.) Do you travel outside of the of your normal area?

A.) I will travel outside of my area if travel expenses are paid such as a plane ticket, hotel, and/ or gas if outside of Tampa/St Petersburg area. If anyone hires a photographer from another area, if you want them bad enough, then this cost should not be an issue.

Q.) How much do you charge for travel?

A.) Just basic travel expenses. A couple may want to consider gas compensation for more than 50 miles outside of Tampa, a plane ticket, and a hotel room.

Q.) What is the purpose of the retainer?

A.) The world of photography is quite fickle. Cancellations happen constantly. Wedding cancellations are quite a big deal. Not only is it an unhappy occurrence, but the couple booked the photographer usually months in advance. The photographer also made sure that no other couple is scheduled for that time and day so the retainer is to secure the day and time and in the case of a cancellation, give the photographer a little something for the time and trouble of planning for that wedding.

Q.) What will you wear at our wedding?

A.) I will dress accordingly based on the client's needs. Either all black, dressier or more casual. If the client has a preference, my wardrobe can accommodate.

Q.) What are your prices and packages?

A.) NO PRICE IS SET IN STONE. I will adjust accordingly depending on the client's budget since everyone deserves the wedding of their dreams.

Q.) Why should we do an engagement session?

A.) Engagement sessions are to announce to the world you are getting married so get ready! Some couples print them out and use them in the decor at the reception or ceremony. Some couples out the photos on their thank you cards or save the date cards or even their invitation. Some use them in engagement announcements in the newspaper. Like a birthday, this will be a moment you need to capture as well. It's the official way of letting everyone know you're ready!!

Thank You...

"For more information about, Alvarez Photography, their information will follow."

Rina Alvarez
Alvarez Photography, LLC
www.AlvarezPhotographyTampa.com
Rina@AlvarezPhotographyTampa.com
www.facebook.com/AlvarezPhotographyTampa
813.784.4158

Wedding Photography Revealed

Michelle Posey Photography

"Answers provided by - Michelle Posey"

Q.) Do you travel for destination weddings?

A.) Yes, but traveling for me is limited since I have two young children.

Q.) So why does wedding photography cost so much?

A.) Because weddings are such a one-shot deal, they have to be done perfectly. There are no re-shoots, do-overs, or second chances. This means photographers have to arrive at the wedding completely equipped to do the best job possible, both in terms of knowledge and photographic experience, and in terms of camera gear and other equipment.

Then, of course, there is the cost of doing business. Any small business needs insurance, computer equipment, usually a license, and those prosaic things like copy paper and pens.

Experience can also be a factor. I can't speak for everyone, but it took me years of photographing professionally before I was comfortable enough to do weddings. Most experienced wedding photographers charge more because you get more from them in terms of being able to be completely confident in the work and product they deliver.

Q.) Okay, so how much will it cost?

A.) My own packages range from $2000 to $6000. In my area, that's in the average range, though certainly there are some priced both lower and higher.

Q.) So when you say a DVD of images, how many are we talking?

A.) I usually deliver around 600 to 800 images from the wedding itself. I also include images from any engagement or bridal sessions. Sometimes it's more, especially for larger weddings that have more to photograph, more time, and more details.

Q.) That does not seem like a lot. Is that all you shoot?

A.) Of course, I shoot more images than that, but the ones I eliminate fall into one of two categories: they are either very similar to other images, or they are photographs that are eliminated because of the subject matter. For example, from all the group photos we take, I pick the ones where people are smiling, have their faces turned towards the camera, and none of the kids are doing something crazy! The second category would include things like photos with unfortunate expressions, dancing-photos that look a little creepy, and the ones where your new brother-in-law made a face in front of the camera just as I was trying to shoot something else!

Q.) Do I get to keep the RAW files?

A.) I don't deliver RAW files. RAW files are practically worthless to anyone other than a professional photographer since most people don't have the expensive software needed to process them. JPEG files are the universal file for printing, storage, and sharing.

Q.) What about the negatives?

A.) It's all digital - No negatives.

Q.) Why do you shoot film?

A.) I don't shoot film. I did shoot film when I first started because that's all there was to shoot. Since I'm one of the old people who started with film, I'm not a romantic about the film; I'm a realist. It looks grainy compared to digital, the color is seldom true to life, and you get only 36 exposures at the most before you are scrambling to change the roll. To me, that's disruptive during a wedding.

Q.) How many weddings do you shoot a year?

A.) Around 20

Q.) So how long does it take for the images to be ready?

A.) It usually takes around two weeks.

Q.) Can I share my pictures on Facebook and other social media sites?

A.) I love for my clients to share images. The only thing I ask is to preserve the watermark because that gives a small measure of protection for both of us against your images being stolen. Believe me, I take this seriously. I live in the state where a wedding photographer created an entire website from images that were stolen, and even made up stories about the couples for her blog. It's an affront to both of us for someone to do this, and I don't want to make it easy for them!

Q.) What if I do not want my images to be used on your blog or in magazines?

A.) Just ask. I shoot for my clients, not for the blogs. Your wishes come first.

Q.) Do we have to provide meals?

A.) I do ask that meals are provided for us; however, it is not written in my contract and I don't consider that it is required. However, we are working very hard for 6, 7, 8 or more hours at a stretch, and we do function better with a little food!

Q.) Do you have a list of partner vendors you work with?

A.) I do not, because there are just too many good vendors around here. I do offer recommendations, especially for Videographers, since there are only a handful of really good ones in my area.

Q.) Do you travel?

A.) Yes!

Thank You...

"For more information about, Michelle Posey Photography, their information will follow."

Michelle Posey
Michelle Posey Photography
mposey@michelleposeyphoto.com
www.michelleposeyphoto.com
www.facebook.com/michelleposeyphoto
501.517.0962

Keith Pitts Photography

"Answers provided by - Melissa Madden"

Q.) Do you only photograph weddings?

A.) I started off only photographing weddings. The combination of photographing children at weddings, being asked by past brides to photograph their new families and having children of my own, I have expanded my brand to include improvisational children's portraiture.

Q.) How do we reserve you as our wedding photographer?

A.) Once you've decided to use Keith Pitts Photography as your wedding photographer, we require a signed contract and a 30% deposit to hold the date.

Q.) What is the Photojournalistic Wedding Photography Style?

A.) Originally the term Photojournalistic Wedding Photography was intended to indicate a hands-off reactive style of photography (like photographing a news event). Currently, photographers are misrepresenting the term by including in their definition stylized posing and exaggerated post production. It is rare to find true photojournalism in wedding photography.

Q.) You take wedding pictures with a digital camera, but do you make inkjet prints?

A.) I've heard that inkjet prints tend to fade. We do not make inkjet prints. All of our prints (digital or film) are printed at professional labs using real photographic paper as well as archival pigment and true platinum prints.

Q.) If you are using a digital camera, how do you make black and white wedding prints?

A.) With digital, everything is originally captured in color. Using my professional discretion I choose which images I feel work best as B&W, I then convert these images using software such as Photoshop. Some photographers do not allow (or severely limit) guest's taking pictures.

I've really never given this any thought. I actually try and give pointers when I can. My mom always told me to "play well with others" - and I took that to heart.

Q.) How do you handle this?

A.) I have never had a problem.

Q.) How should I find a wedding photographer?

A.) First and foremost, ask your friends and/or your coordinator for referrals. Secondly, try to narrow it down to photographers that speak to you, not necessarily photographers that just show pretty work. When you are looking through their images on their website, they should grab you. Then when you interview your photographer, make sure they are someone you get along well with. You will be spending a lot of time with your photographer! If you are not wowed by any of the referrals, I would look at local wedding publications and perform a Google search to find a photographer that really speaks to you.

Q.) What questions should I ask a prospective wedding photographer? Better yet, what should I ask the photographer doing our wedding?

A.) Hands down, the most important question that you can ask your potential wedding photographer is how much experience they have. The more experience you have, the more likely you will be able to handle any situation should it arise. There are some very good new photographers and if nothing goes wrong, they will probably do a good job for less money. BUT, if your budget allows, I would recommend the insurance of experience and choose a photographer that has shot many weddings.

Q.) You do wedding photography part time - shouldn't I be looking for someone who shoots weddings full time?

A.) We are a full time, full-service boutique photography studio for the past 15 years.

Q.) Do you have a page of wedding links?

A.) On our blog, we have links to local wedding vendors. Two times per month, we dedicate a blog post which features an in-depth interview with a local wedding vendor. I am planning a 5:00pm wedding, with a departure via a stretch limo. Obviously, photos of the departure are important to me.

Q.) When does the sunset and how late can a photo be taken and still look good?

A.) There are many variables in this question which is why experience becomes such an important factor when hiring your wedding photographer. We like to discuss the timeline with the bride/planner ahead of time. We discuss the day's sun travel times and consult with the bride/planner about what the light conditions will be at that time of year and location. A photograph should look good at any time of the day - if it is well after sunset, then it will most likely require flash and will look good, just different from natural light.

Q.) Do you travel out-of-state to do photography?

A.) Yes, we often travel to photograph weddings.

Q.) Do you create wedding albums for your customers?

A.) Yes, we are a full-service boutique photography studio offering a variety of custom handmade wedding album options.

Q.) Is it important for my photographer to shoot medium format as opposed to 35mm? Or, what wedding photo equipment should he use?

A.) The equipment the photographer is using is far less important than the results that he or she gives you. If their work speaks to you, it doesn't matter what equipment they used. While we use a combination of different formats including digital, medium format, large format, and rangefinder (film) - that isn't why I am hired. The bride and groom hire me because something about my photographs grabs them. In the end, you are looking at the photograph not what camera was used.

Q.) Do you make exceptions to your criteria list?

A.) We realize each wedding is unique and try to be as flexible as we can.

Thank You...

"For more information about, Keith Pitts Photography, their information will follow."

Melissa Madden
Keith Pitts Photography
www.keithpittsportraits.com
www.blog.keithpitts.com
480.656.3567

Chapter 11

Viva Expressions

"Answers provided by - Jorge Gonzalez"

Q.) Do you back up the images you take at weddings?

A.) It is crucial to make a backup of photographs taken during a wedding event. The first step to take after shooting a wedding is to download all photographs to the computer's hard drive and save a copy of that file to an external drive. Then, every photograph is edited and saved using the same procedure. A DVD copy is also kept out of our home-studio to make sure that we always have a copy of all pictures if a casualty happens. I highly recommend not deleting the photos from the camera's memory card until you have enough backup. By following this process, we guarantee that such important work is safe and far away from any issue that may happen with the computer.

Q.) Will I get my photographs on a DVD?

A.) All our packages include a DVD containing all our selected photographs. I say "selected" because during portrait sessions, a style of our wedding photographs, several shots are taken to ensure that every person in the shot has good posture, eyes open, etc., in order for them to be part of a harmonious group. From repeated shots, one is selected from every group to avoid lethargic moments to the viewer

when looking at similar photos several times. I practice the same principle in other shots taken during the ceremony.

Q.) Are the pictures on the DVD edited?

A.) The DVD handed to my customers contains edited photographs. As a professional photographer, photographs must be taken in RAW. A camera raw file contains all data from the image sensor which facilitates the editing process such as red eyes, cropping, color, contrast, etc. It also provides a better opportunity to have fantastic photographs! After editing, I save the photographs in JPG format and create two files on the DVD. One file contains high-resolution photographs to allow my customers to print in large sizes such as 36x30 without sacrificing quality. The second file has compressed photographs to be used on-line for emails, social networking, etc.

Q.) Why will I order pictures from you if I receive a DVD with hi-res images?

A.) First of all, because they are my photographs, and as a professional photographer, I want them to be carefully printed on high-quality paper, which is crucial, and with an excellent printer that is well set up to reproduce with fidelity the images of my professional work. Having professional photographs printed at convenience stores brings disappointment because they come up a little different from the DVD's images. It is one's call to make decisions about saving money and to get poor and short lasting photographs. By having my customers' photographs printed in my home studio, I guarantee high-quality prints and durability.

Q.) How many pictures will I have on my DVD and do you include all of the pictures you take?

A.) I have estimated from 60 to 80 photographs / hour. I hand my customers a DVD with most of the photos taken. As

I mentioned above, several photos are taken to reflect a certain moment, but I choose the best one to be part of my final version of the photographs. Also, there are several times, in which I am about to take a picture and someone walks in between me and my object, so these photos must be deleted. The DVD handed to my customers will contain a written printing rights release, in order for them to print wherever and whenever they decide.

Q.) Why will I take bridal portraits or engagement session before the wedding?

A.) These photographs sometimes are used by my customers during their wedding reception. It is beautiful to see a large photograph of the couple showing happiness and excitement! Also, they may decide to include these photographs as part of their signature book for their guests to sign. Since photography involves a huge part of relationships, meeting the couple actively provides the opportunity to discover their best angle, interact with them, and learn about their personalities in order to find a better way to approach them effectively and vice-versa. Having this session done before the wedding reduces anxiety and stress, and builds higher confidence and understanding.

Q.) When do I book my bridal/engagement/boudoir session?

A.) It is optimal to set up the engagement session date when the wedding contract is signed. I have had some couples who have used a beautiful engagement photograph to create their save the date cards, favors, etc. It is my customers' decision when this session may take place depending upon their needs.

Q.) How long is the portrait session?

A.) The portrait before the wedding as well as the engagement session last one hour in order to have enough photographs to choose from.

Q.) What to expect at the bridal portrait session and can I take bridal portraits at the wedding instead of booking a separate session?

A.) I prefer to have portrait photographs taken in real time because that is the actual day! It is true that we have to deal with more stress, but I have an assistant, which is crucial when organizing groups and helping with postures in order to get great outcomes! I always capture portraits of the couple's family such as parents, grandparents, siblings, grandchildren, etc., as well as the bridal party. It provides better choices for the couple when making decisions about what photographs will be included in their prints and/or wedding book, which is included in our packages.

Q.) Where will you photograph our engagement session?

A.) Since I am located in Florida, Gulf of Mexico, sunsets are just marvelous; therefore, we take most of them from the beach late in the afternoon; at that time light is perfect for photographs. I also go to certain parks that are rich in vegetation, flowers, nature, etc. I have encountered some couples asking for special restaurants or places where they met for the first time, which involves a deep sense of memories. I highly recommend the beach, and there are some specific places with few people around where the couple has more privacy and freedom to be as they are!

Q.) What should I wear to an engagement session?

A.) This is the moment to show how the couple is on a daily basis. These photos also show spontaneity, truthfulness,

love, and commitment due to the fact that they are free of stress and alone. I highly recommend light colors for her and a white shirt and blue jeans for him if the photographs are taken on the beach.

Q.) How long before I see my proofs?

A.) It takes about two weeks to have the galleries ready for my customers to see. All selected photographs are shown on my website under a private gallery. The gallery contains sub-galleries that tell the story of the whole event; I start with a "getting ready" gallery, then "ceremony", "portraits", "other portraits", and "reception". In addition, I mail the DVD containing the two files. Sometimes it's easier for them to make the selection from this format.

Q.) When do you typically arrive at the wedding and what to expect on my wedding day?

A.) My assistant and I arrive almost always thirty minutes before our contracted time. Depending on how far is the place we have to go, we leave our home-studio with enough time to be there at least one hour in advance to prevent any issue that can occur while driving to our customers' location.

I share important and helpful tips in advance with my customers in order to rehearse and coordinate with their bridal party, family, and friends. These tips are an effective help to get better photographs and provide my customers with a better idea about what is expected from them.

For example, if "getting ready" photographs will be taken, I recommend to keep the room organized and to listen to my directions. I understand that sometimes following tips is hard due to stress, but reading in advance helps to assimilate the information and everything becomes easier and smoother. During portraits, groups can be organized by forming a "pyramid" shape, so taller people are in the center,

shorter people are at the ends and children can sit down in the center of the group.

Several postures can be adopted such as the couple kissing while the whole group, including children, is looking at them with surprise! For candid photographs during the reception, I encourage the couple to create moments, such as interacting with all their guests, including children (these are very sensitive!), as well as walking around and doing "crazy" things, dancing, hugging, kissing, jumping, etc.

Q.) What is a first look?

A.) It is the first impression of the groom looking at the bride while she walks down the aisle towards him! These photographs always show a combination of feelings, emotions, and sensitiveness.

Q.) What is an "after" session?

A.) It is a portrait session scheduled for the next day of the wedding. Also, it can be scheduled to be after the honeymoon. Generally, includes just the couple, but also can include the wedding party and family.

Thank You...

"For more information about, Viva Expressions, their information will follow."

Jorge Gonzalez
Viva Expressions
www.vivaexpressions.com
info@vivaexpressions.com
727.232.0597

Chapter 12

Fotowerks Custom Photography

"Answers provided by - Terry B. Bruno"

"Featured within and on the covers of publications like Alabama Weddings Magazine, B-Metro Magazine and Birmingham Magazine, the photography and special VIP treatment of a bride and her guests by Fotowerks is second to none.

Fotowerks is an established and vibrant company that has emerged as the defacto standard for wedding photography. By balancing superior client care with world-class publishing quality photography this group remains one of the most sought after wedding photography companies in the industry. The brilliance of Fotowerks shines brighter and brighter with each new satisfied client.

Fotowerks has made its mark by continually going above and beyond all expectations and breaking the industry rules by insisting that their clients be educated and involved in planning their wedding photography. There's only one chance to get a wedding right... and Fotowerks does.

Bold, beautiful, demure, romantic, silly, fun, exotic... anyway you can imagine, Fotowerks has you covered. Brides of distinction realize the importance of capturing this special day. For those clients, there's Fotowerks." – Terry Bruno

Q.) How long have you photographed weddings?

A.) I personally photographed my first wedding in 1992. Together our crew has over 50 years of experience! Our new photographers are required to work as an assistant or a candid photographer until such time that their skills and client interaction perfectly match Fotowerks expectations.

Q.) Do we get a disc of high-resolution files?

A.) We do offer our clients both high-resolution DVDs as well as CDs with web sized images for social networking. You can choose to have either a print release OR full ownership of the images. Print release will allow you to print any image from the disk anywhere, anytime. Having full ownership means that you will own the images exclusively and we will not keep any backup of those images nor will we use them in any of our promotional material.

Q.) How many photos should I expect to receive?

A.) The number of photos will vary based on the size of the wedding. For instance, if you have a wedding that has 600 guests you will receive more images than a wedding with only 100 guests. For the most part, you can expect to net between 200 and 500 images.

Q.) Do you give us every photo you take?

A.) No, we wouldn't want to give you a photo of you with your eyes closed, now would we? We have a stringent process that requires going through each individual image to ensure that it is not only technically sound, but represents you and your wedding day in the best light possible!

Q.) Can we give you a list of photos we want to have taken?

A.) Most certainly! I always provide my brides with a supplemental shoot list. We will always get the standard

shots, but in order to forgo being a mind reader, I need to know what each bride likes. We put together each wedding day photography session much as a movie would be done. That includes production meetings, call sheets, and shoot lists.

Q.) Do you edit your photos?

A.) We hand edit EACH photograph that you will be provided. We do not batch edit our photographs, we will even remove blemishes, exit signs, etc., from your formal photographs!

Q.) How long after the wedding will we receive our photos?

A.) Your photos are generally ready between 10 and 14 business days. Sometimes sooner! I love to have the galleries live before the couple gets back from their honeymoon!

Q.) Do you back up your photos?

A.) We do. Not only on DVD, but our photos are on hard drives as well as the cloud and at our off-site lab. That ensures that we will be able to access your photos even if something goes wrong with other backup methods.

Q.) What kind of equipment do you use?

A.) We all use Nikon equipment. Each of the photographers will have a backup camera, many lenses for various uses as well as spare batteries for all of it! We also have various studio equipment and many computers!

Q.) Do you travel outside of your general area?

A.) We travel all over the world. We have passports and all documentation needed for destination weddings.

Q.) How much do you charge for travel?

A.) If the location is within a hundred mile radius of our studio, there is no extra charge. Beyond that, it will depend on the destination. For the most part, we have the client cover travel, lodging and a per diem for meals.

Q.) What is the purpose of the retainer?

A.) The retainer holds your date and is deducted from the total price of your wedding day photography services. This will ensure that we will be there on your wedding day and not book another wedding for your crew.

Q.) What will you wear at our wedding?

A.) We wear dark pants, dark shoes and our black Fotowerks polos. We prefer to be ninjas and not draw attention to ourselves. YOU need to be the one everyone notices, not your photographer!

Q.) What are your prices and packages?

A.) Since each wedding is different, we customize packages to suit both the couples wants/needs and budget. We also offer no interest payment plans that allow you to really stretch that budget!

Q.) Why should we do an engagement session?

A.) An engagement session will allow you to become comfortable with your photographer prior to your wedding day, as well as allowing you to have some awesome photographs of your gift(s) or sign in table!

Our Philosophy

"Our philosophy is simple.

People deserve to have their photographic memories captured and preserved with great care and great attention to detail.

It's a simple idea, but it's one that seems to be a lost art in the world of photography today. Not many businesses follow the simple premise of the golden rule. And that's a shame.

That's why we work so hard, not only on our photography skills, but also on our technology, social media, and business practices. We believe that you deserve, great photos and someone you can get on the phone when you need them. Don't forget quick turnaround and delivery of items and easy, flexible ways of ordering and paying. On top of it all, you need to know that you're dealing with people who have mastered these tasks so that when you're being photographed - you are enjoying calm cool professionals that only have to concentrate on putting you first.

The photos are important, that's why you've hired a pro. But at Fotowerks we always remember that it's the blend and balance of all these things that makes us the right choice. You deserve the best."

That's why there's Fotowerks...

Thank You...

"For more information about, Fotowerks Custom Photography, their information will follow."

Terry B. Bruno
Fotowerks Custom Photography
www.fotowerkscustomphotography.com
www.fotowerking.com
Info@fotowerks.net
https://www.facebook.com/fotowerkscustomphotography
205-665-9970

Benchmark Publishing Group

Chapter 13

Samuel Guss Photography

"Answers provided by - Samuel Guss"

Q.) What type of photography do you do?

A.) Mostly journalistic, storytelling weddings with side work in family portraits, senior portraits and model portfolios. For weddings, I do a lot of candid detail shots before the wedding while the bride and groom are preparing; this is also when we get some of the formals with the bride and her bridesmaids and the groom with his groomsmen. Photos of the wedding itself are done in a narrative style, and I like to get as much of the original event as possible. I will do truly formal (posed) photos if requested, but I find that more relaxed and natural "formals" are more satisfying for my clients and capture the event more beautifully.

Q.) What kind of equipment do you use?

A.) I use an older model digital Cannon with new lenses. A camera is just a vehicle for the lenses and the photographer's eye. I will be expanding into a newer model Cannon by the end of the year to cut back on lighting equipment, however.

Q.) Do you take posed family images?

A.) Yes, as requested.

Q.) Can we give you a shot list?

A.) This is not only welcome, but infinitely helpful. My wife is my partner and assistant and usually, helps keep track of desired shots.

When we're given a list, we use it as a base guideline for the photographs taken that day - meaning that of the thousands of shots taken, we will take care to capture those images, but they will not be the only images.

Q.) Would you travel for my wedding?

A.) Yes. We've traveled as far as West Virginia and South Carolina from our home city of Birmingham, Alabama.

Q.) Do you typically arrive the day before the wedding ceremony for destination weddings?

A.) Yes, and even for local weddings, we prefer to attend the rehearsal so we can get a feel for the blocking and pacing of the event, lighting conditions, and so forth. I also feel it's important to be on the same page with the caterer, Dee-Jay, Videographer and wedding planner, to avoid any confusion and make sure we're all working together to provide the best experience for the families.

Q.) Are you the only photographer?

A.) Yes, though my wife Chauma has helped when needed and I have occasionally used other professional photographers for particularly big events.

Q.) How long will it take to get our images?

A.) For a standard wedding, it may take six to nine months for photo editing and selection, proofs, and post production (parent books, albums, and so forth). This is true regardless of budget, the extra time is sometimes necessary to clean up photos that didn't resolve correctly, get the wedding pages just right and so on. I have found in this business one can pick two out of three things: low cost, great quality, fast

turnaround. Samuel Guss Photography focuses on low costs and great quality.

Q.) Can we see all of the photos from one of the weddings on your website?

A.) By request, I make photos of other weddings available. I also have an extensive online album from many of the weddings I have worked with.

All wedding galleries are password protected, but I work with couples up front for using their gallery as a portfolio.

Q.) How many photos are included in our album?

A.) It depends. Usually 20-30 "primary" photos and then about half again as many for details and background images that work with the primary photos.

Q.) How does the album design process work?

A.) I upload the proofs to your password protected page on my website.

You will select the images you want in the album itself and give me that feedback. I will then design the pages based on our mutual discussion and then give you the option to approve or request changes in your page/album design.

Q.) What if we need to make changes to the album?

A.) You will have the opportunity to proof the album online prior to ordering and I make allowances for up to two major changes.

Q.) What album design software do you use?

A.) Old fashioned photo editing software. Your pages are actually complete prints in themselves (transposed to the album pages) regardless of the number of images.

Q.) How many photos do you take per wedding?

A.) This varies depending on the lighting and the technical difficulty of the location. A very good photo-shoot may have as few as 400 photos.

Under challenging conditions, I try to take more photos of each element in case I have to retouch an image or discard several drafts.

On average I take around 600 photos, of which all become available to the client and 200+ usually get edited.

Q.) Will guest be able to order prints directly from your website?

A.) Yes, this is available.

Thank You...

"For more information about, Samuel Guss Photography, their information will follow."

Samuel Guss
Samuel Guss Photography
www.samuelgussphotography.com
samguss@gmail.com
205.327.8155

Erin Johnson Photography

"Answers provided by - Erin Johnson"

"Erin Johnson Photography is a boutique photography studio. We are quirky, light-hearted and passionate about every part of our business. We're interested in being sincere, attentive and exceptional. We want to learn about you and create images for you. We want to photograph your life in every season: starting with your engagements, onto your wedding and into your future with all the milestones and celebrations that come along. Because we want your photos to be unique to you, we offer styling for every session. This includes helping you select a location, your clothing and custom props. This will make you LOVE your pictures even more and feel great about how you look in them!" – Erin Johnson

Q.) What is a good professional photography background?

Schooling can be helpful but isn't necessary but can be helpful. If the photographer is running a business then studying business would be smart. Obviously, they need to know how to use their camera and create good photos. I wouldn't say there is a time frame on this, it depends on the person. K owing how to deal with people is important also.

Q.) What is your specific Wedding Photography style?

My style is fresh, romantic, quirky and timeless.

Q.) How do you, the photographer, dress for a wedding?

I typically wear black. A black dress in the summer and a black suit when it's cooler would be ideal.

Q.) Will you personally be the photographer at our wedding, or will it be an Associate?

We have both. It is written in the contract who the client hires.

Q.) Do you double book?

Each photographer will only photograph one wedding a day.

Q.) Will you be at our event for the entire day?

We are booked based on hours. It's up to the client on how many hours they would like. Typically, we are hired for about 8 hours.

Q.) Can we have photos taken of us getting ready?

Yes, we love these!

Q.) Do you use have backup equipment?

Yes, of course!

Q.) In the unlikely event that you become ill, do you have an equally great photographer to cover our event?

Yes!

Q.) How long does it take to see our photos?

4-6 weeks.

Q.) Can our family and friends also view and purchase photos online?

Yes, we use Pictage.

Q.) How long will it be before we receive our completed Wedding Album?

Once the design is finalized, it takes 6-8 weeks to get the album.

Q.) What is the process for creating our Wedding Album?

The client selects the photos, then the studio creates a design. This takes 3-4 weeks. Once the design is done the client can make changes until the album is perfect.

Q.) How long will Wedding Albums usually last?

As long as they are taken care of they should last decades.

Q.) Do you also do the standard group and family shots, even though your style might be more candid?

Yes, and we have a list to help.

Thank You...

"For more information about, Erin Johnson Photography, their information will follow."

Erin Johnson
Erin Johnson Photography
www.erinjohnsonphoto.com
mail@erinjohnsonphoto.com
612-529-9792

Benchmark Publishing Group

Chapter 15

G.E. Masana Photography

"Answers provided by - G.E. Masana"

"G.E. Masana is a NYC, NY, based wedding photographer known for his coverage of real moments with illustrative art photography. He's been featured in leading professional photography journals, RANGEFINDER and STUDIO PHOTOGRAPHY MAGAZINE, and published in nationally renowned wedding magazines such as MARTHA STEWART WEDDINGS, THE KNOT, BRIDES, ELEGANT BRIDE, BRIDAL GUIDE and TOWN & COUNTRY WEDDINGS among others." – G.E. Masana

Q.) What are the advantages of hiring a professional wedding photographer as opposed to having a friend or family member take the pictures?

A.) Maybe it's because people are used to pocket cameras where they only need to point and shoot, but they think all there is to photograph a wedding is pointing a camera at it.

But owning a camera doesn't make someone a photographer. It just makes them a camera owner.

I only wish to own a good pair of shoes made me into a better dancer.

Cameras don't take photos - but people do. And weddings offer up the worst case circumstances for photography!: Dark Venus. Harsh sunlight. Rain. Lighting from different

color sources. And an all-white gown that makes proper exposure critical, or lose the details in it.

Non-pros are also likely photographing in JPG format, a setting which has the camera-making decisions on how the image will look based on a one-size-fits-all algorithm. It retains less detail in the highlights and shadows as it compresses the file, and when it does that, it deletes half the data, substituting color tones for their next closest match. It's not the best format for this type of work, but that's the format most cameras come with.

Besides those technical issues, there's also the non-camera nuances of the wedding day.

I was a guest at a wedding once where at the moment in the ceremony when the priest produced the wedding rings, an audible "OH!" came from way back of the church. The photographer, a friend of the family who had volunteered for the task, had suddenly realized he was in the wrong spot to get what was obviously about to happen in the next few seconds, and made a very noticeable - and distracting - 20 yard dash up the aisle.

But when you photograph weddings continually you get to know what to expect so that you're there when it happens. It can even be as barely noticeable as watching someone's eyes to get a hint of what's coming next.

Relatives and friends are well-meaning of course, but they haven't experienced this.

It will make a big difference though in the outcome.

Although the day may appear chaotic to the observer, the seasoned pro knows what comes next. Experience teaches how things pan out at weddings and what the pitfalls are and how to avoid them so things go smoothly. The pro has a reliable plan and the proven ability to move forward and get

what they need in the way of photos, no matter what happens at the wedding.

And then, if you thought the weather and lighting conditions were the only variables, guess again! The biggest variables are the people the photographer is in contact with throughout the day. I've had guests step in front of my camera to ask me a question about photography just as the bride's grandmother was about to hug her and I was about to get the shot. I can't say how a relative might react were that to happen to them, but a professional has to maintain an easy demeanor, mustn't be self-centered, must be patient, must be tactful and remain mannered and polite, even when things don't go quite right.

And not to be overlooked is the fact that one can either be part of the festivities or be there to document the festivities, but it's awfully difficult, if not downright inadvisable, to do both without compromising the assignment. One of my 'rules" is to keep the camera up to my eye even when I'm happy with the shot I've gotten, because you never know if the next second will bring an even better shot your way. But if I'm putting the camera down to share a conversation or a drink because I'm also a guest - obviously I lose the shot.

You can't do both.

Q.) Why do wedding photographers copyright the pictures they take at weddings? Is this common?

A.) You can't escape it, really. By law, copyright is established at the instant the shutter's clicked.

And there's a significant reason Uncle Sam's copyright law exists.

As the image copyright holder, photographers then have the right to use those images to build a portfolio with which to market their services and continue to have a livelihood.

No one else is legally permitted to undermine that and use the same images to market themselves. It would be unethical if they did, but without the law, it wouldn't be illegal.

Photographers also then have the right to sell the images they own as part of making a living.

Brides and grooms often mistake "copyright ownership" with "printing rights." The couple may wish to print the images for their own personal use. When that's the case, they don't need to own the copyright.

All they need are the printing rights assigned to them by the copyright holder.

Q.) Is it better to book a wedding photographer who uses film or digital equipment?

A.) It's a question of what end result do you want to get? You can make great art with either crayons or oil paint. Film or digital.

The process itself doesn't matter. It's only a means to an end, and the end is the image.

Those photographers who prefer film do so because of its results. They like the look of film.

I prefer digital because I can do more with it than I could ever do with film.

Q.) What is a proof and what are the advantages of the different types of proofing?

A.) "Proof" is an outdated word that came from the 1960's (or prior) to denote a first run print that was stamped "proof" across its face and typically faded in a few months. It survived long enough to do its job which was to give the client an idea of what the image looks like.

Now with digital, "proofs" can be regular prints, but more often they're image files viewed online.

There's actually a disadvantage to seeing them on a computer. The computer's colors and resolution will make the image file appear different than it actually is, from monitor to monitor.

Q.) What are the pros and cons of hiring two wedding photographers to take pictures at a wedding, as compared to only having one photographer taking pictures?

A.) The only advantage to having a second photographer is about logistics. If it's a situation where two events at two different locations need to be photographed at the exact same time, then you obviously need two photographers.

Otherwise, I don't see any advantage… as long as the sole photographer is a great one.

Here's why:

The second photographer is typically a lesser experienced photographer learning the ropes. Therefore, their work isn't usually top quality.

The second photographer needs to be art directed otherwise they compete for the same shots, same angles as the first photographer. But doing that only creates redundancy, not more coverage. So very often, when a studio puts two photographers on the job, the two photographers clash.

Most studios don't bother art directing the second photographer because many studios offer the second photographer only as a way of seemingly adding value to their offerings. It's more a marketing matter than a practical matter. It's the thinking "two is better than one" will have the bride and groom perceive them as a good deal.

But that's not the case anymore than having two cooks in the kitchen is better than one. Because every photographer is unique to themselves, two photographers' photos side by side in a wedding album will look like two photographers took them. The lighting, the compositions, and even the quality of the photos themselves, will not be congruent.

And second photographers tend to show up in the first photographers photos too! They take a photo and then just stand there looking at the back of the camera to see how it came out because they're unsure of how it came out. I had that happen when I used to freelance for other studios all the time.

Q.) What types of wedding packages do photographers typically offer?

A.) Those who offer packages typically look to include items that are popular with brides and grooms. At the time of this writing, that would primarily be wedding albums, enlargements and DVDs of the image files.

Q.) What is the customary deposit to put down, to reserve a photographer for a date? When is the balance typically due?

A.) This varies, but it's typically a significant percentage up front. This helps assure the couple mean business because the photographer is likely turning away all other inquiries for that date.

Balances are commonly paid before the wedding because photographers love taking photos, but hate becoming bill collectors. Chasing brides and grooms for months after the wedding for the final payment isn't fun. Unfortunately, after the wedding that can happen. Pregnancies, car repairs, new furniture and other expenses may encourage newlyweds to bump the due payment back and all we want is to get paid

for the work photographers have done. To avoid the possible hassle, photographers ask for balances prior to the date and then they're free to proceed with all the post-wedding work without any ugly "payment collection" issues to worry about for either the photographer or the bride and groom.

Q.) Why is there such a large price range among different wedding photographers?

A.) Just as no two individuals are alike, neither are any two photographers. There are different levels of experience, talent, knowledge and skills.

There are different types of reputations. There's varying degrees of service from poor to excellent. This is all on top of what it costs any photographer to be in business which is all across the board. And even then, some carry on having the spouse supporting them. Or they may be living off an inheritance. Or have a day job that takes care of their bills.

Some photographers are actually priced to go out of business! I saw it in the news just today. Another studio closed and left couples without their photos. It's not ethical and unfortunately the bride and groom wouldn't know it until it happens. The old adage "if it sounds too good to be true" applies here.

Q.) At what point in the wedding planning process should a couple book a wedding photographer?

A.) This is because a photographer is one person, and unlike any other photographer, if that one person's skill, eye and talent is really desired by the bridal couple, then the sooner they're contracted the better. Otherwise, you'll have to do more legwork to find a second choice to go with.

Some couples book with studios who hire photographers as independent agents to photograph their weddings, and many of those studios will assign whomever they have. So the bride

and groom aren't concerned with "who" when they deal with those studios or they wouldn't be dealing with them. But even so, it does get to a point where you wouldn't want the guy they use that's way down their list, which can happen when you're the fifth wedding they have on the books for the day but regularly employ 4 photographers, for example.

Q.) What should a couple look for in a wedding photographer?

A.) Number one is the work itself because no matter what else, that's what they'll end up with.

With wedding photography, there's no barrier to entrance anymore. And so there are many photographers today actually learning their craft at the weddings they photograph and I expect that number will grow.

Currently I give brides and grooms 20 questions they need to ask photographers - they're the 20 questions I ask based on my industry knowledge about photographers - so it's more insightful than the standard questions you see on bridal magazines and wedding forums.

One of my questions is to ask the photographer what makes him or her decide to trigger the shutter at any given moment. I want to hear that they're finding stories, documenting interactions with loved ones, action and reaction, sequences of events, fleeting little moments that show heart, as this adds dimension to the images - and not just snapping away randomly at anything that may look pretty. Anyone can snap away.

I feel since everybody today has a camera at a wedding, if you're going to invest funds in having a photographer, and then they have to create something for you above and beyond what any guest would be able to do.

Q.) What should a couple beware of with certain wedding photographers?

A.) Besides the obvious poor service and bad work, the thing to avoid is the photographer with the bad attitude or the prima Donna mentality.

Of course, that's not always so easily identifiable. Most times you don't know it's there until it happens at the wedding.

There's a couple of techniques I know of, for getting a read on the photographer up front when you first sit down with them, which will give you a pretty good sense of what to expect.

I've figured these things out myself because in hiring photographers to work with me over the years I certainly wanted to avoid anyone that may present themselves less than professional when the wedding gets a little chaotic.

They're more detailed than I can get into here, but it's about knowing what clues to look for when you're face to face with the prospective photographer. Things like reading between the lines of their testimonials. Asking leading questions. It's like being a detective!

Q.) How should a couple determine their wedding photography budget?

A.) Bridal magazines and planners may suggest a percentage of the overall budget, but that's not realistic because photographer prices aren't uniform. And neither are wedding budgets.

The smarter planners will advise that no matter your overall budget, allot more only for those items that are the most important and dear to you.

Q.) What equipment should a wedding photographer have?

A.) Theoretically, a great photographer should be able to make images with a borrowed cell phone that makes you drop your jaw in awe.

But give that photographer a professional camera and the sky's the limit.

It's a tool. So like a race car is a tool for its driver, the better a camera's engineered and the higher the performance it's capable of, the skilled photographer is able to make it do what he or she wants it to do.

Look at the portfolio because that's what to expect no matter what tools were used. Just like you'd test drive that car to check it out, but not the tools used to manufacture it.

Q.) Do prices typically vary for off-season or weekday weddings?

A.) Depends how the photographer runs their business.

It's a personal labor on the wedding day and afterwards, working on the images, working on the order.

It's the same amount of personal work regardless what day the wedding falls on. Expenses are the same too.

So it doesn't matter if a day is off-peak because it has more to do with how many assignments annually the photographer can handle, not the days they happen to fall on.

That being said, it doesn't hurt to ask, but be prepared whichever way the answer goes.

Q.) Is it possible to get black and white photographs as well as color photographs, or do couples typically have to decide between one or the other?

A.) With digital, everything is photographed in color. Then in post production, a decision can be made to convert to black and white.

But making black and white images isn't simply a matter of deleting the color.

Certain images are better candidates for black and white than others.

A dramatic image may make a stronger statement in black and white, for example, whereas another image may look muddied if converted and would be better in color.

It's wise to at least confer with the photographer about which images to render black and white to get their opinion. I can pretty much visualize what an image will look like in black and white so that helps in selecting the best candidates.

G.E. Masana has a wedding client list that includes Jen Chapin, singer songwriter and daughter of the legendary Harry Chapin; Vanessa Penna, Editor, ELLE; Gaines Peyton, co-owner Sears-Peyton Gallery, NYC; Diana Bloom, Photo Coordinator for Victoria's Secret, NYC; Evan Galbraith, son of Evan G. Galbraith, former Ambassador to France; Randolph Pratt, son of Pfizer Pharmaceutical's Chairman Emeritus Edmund Pratt; Timothy Breese Miller of the New York City Metropolitan Opera; Rebecca Odes, author and co-founder of gURL.com."

Thank You...

"For more information about, G.E. Masana, their information will follow."

G.E. Masana
G.E. Masana Photography
www.gemasana.com
studio@gemasana.com
646.543.1321

Benchmark Publishing Group

CONCLUSION

Congratulations! You now have the combined knowledge that all of our interviewees have been generous enough to share! We hope that you now feel confident and excited to go out and plan your special day. Before you get started, though, we'd just like to share a little more advice with you:

In all likelihood, you are only going to have one wedding. This also means that you're also only going to have one time in your life when you are planning your wedding. Our advice to you is to not make just the big day the only fun part. We truly hope that you enjoy the process of planning your wedding as much as you enjoy your wedding day.

All too often in life, we put all of our focus on the end result and we lose sight of the fact that the journey, not just the destination, should be exciting and enjoyable too. We hope that you find enjoyment in your wedding planning journey. We hope that you cherish each moment of planning your wedding, even if unexpected things still happen along the way. Always remember that life would be boring if everything always went exactly as expected. When unexpected things happen, try to smile and accept it as part of the journey.

We have done our best to compile the best advice that we were able to find, from true wedding industry professionals. Even though you now have a substantial advantage over couples who plan their weddings without the knowledge that you now have, there are still bound to be some bumps in the road, in the days leading up to your big day. As with all things in life, it's not what happens to you throughout the wedding planning process, it's how you handle those things that happen to you along the way. Embrace the challenges

and welcome the unexpected. Each challenge that you resolve will bring you one step closer to your big day.

We wish you all the best as you plan your wedding. May you find happiness, excitement, and fun in all of the days leading up to your wedding, and beyond!

Wedding Photography Revealed

www.ingramcontent.com/pod-product-compliance
Lightning Source LLC
Chambersburg PA
CBHW060357190526
45169CB00002B/645